Kandinsky: Incarnating Beauty

T0017178

David Zwirner Books

ekphrasis

Kandinsky: Incarnating Beauty
Alexandre Kojève

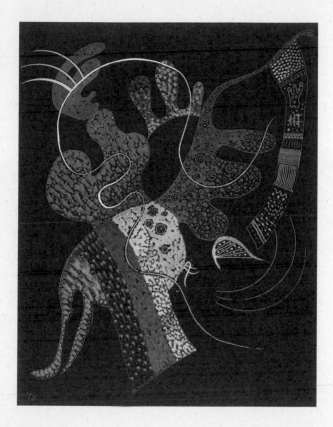

Wassily Kandinsky, *The White Line*, 1936. Gouache on black paper mounted on cardboard, 19 ⅝ × 15 ¼ inches | 49.9 × 38.7 cm

Contents

Introduction

Boris Groys

The texts that are collected in this book make up an exceptional, isolated group within Alexandre Kojève's philosophical oeuvre. They are his only writings explicitly dedicated to a discussion of art and artists, an exploration prompted by his relationship to his uncle Wassily Kandinsky. Born Aleksandr Kozhevnikov in Moscow in 1902 to a wealthy family with connections to the cultural circles of the time, Kojève emigrated to Germany following the Russian Revolution, was awarded a doctorate in philosophy by Heidelberg University under the supervision of Karl Jaspers, and then moved to Paris. Kandinsky's trajectory was similar—soon after the revolution he emigrated from Russia to Germany to teach painting at the Bauhaus, and after the Nazi government closed the school in 1933, he, too, moved to Paris, where he was largely unknown. The immediate goal of Kojève's essay "The Concrete Paintings of Kandinsky," written in 1936, was to present his uncle to the Parisian public. Despite writing the text for a particular and even personal reason, Kojève used the opportunity to formulate his general theory of art. With historical distance, this essay presents itself as one of the major texts on modernist art written in the period between the two world wars. The letters from Kojève to Kandinsky that are also included in this publication demonstrate Kojève's interest in the artistic life of his time and his reactions to the exhibitions of such artists as Picasso and Braque. The short posthumous note on Kandinsky further highlights Kojève's admiration of art while honoring the life and character of his uncle.

Kojève became famous mostly due to his seminars on Hegel's *The Phenomenology of Spirit* given at the École Pratique des Hautes Études in Paris between the years 1933 and 1939. His course was regularly attended by leading figures of the French intellectual circle, including Georges Bataille, Jacques Lacan, André Breton, and Maurice Merleau-Ponty. Even though Kojève insisted that he wanted to repeat the main trajectory of Hegel's thought, he de facto substituted Hegelian "spirit" with "desire" as the force moving world history. This explains why the leading theoreticians of surrealism, then in search of a new and universal theory of desire, participated in Kojève's seminars. However, as Kojève's text on Kandinsky shows, Kojève's own theory of art was far from the surrealist one.

The central notion around which Kojève builds his text on Kandinsky is "beauty." For Kojève, artwork is different from all other things in that its only reason for existence is beauty. Other objects in the world can be beautiful, but the reason they exist is different—they are natural objects, such as trees, or artificial objects that have certain utilitarian functions. However, artworks exist only if they are recognized as beautiful—otherwise they land in the garbage and disappear. But what is beauty according to Kojève? For him, the notion of beauty has nothing to do with an object being pretty or ugly. It has nothing to do with aesthetic experience or taste. Instead, beauty is a value. An artwork is beautiful if it is recognized as valuable and

is thus maintained and saved from disappearance, from nonexistence.

The notion of recognition is central to Kojève's interpretation of Hegel's *Phenomenology* as a phenomenology of desire. In the framework of his seminar, Kojève speaks about the desire for recognition as the basic human, even "anthropogenetic," desire. It is this desire that is a motor of history: "Human history is the history of desired Desires.... Self-Consciousness, the human reality ... is, finally, a function of the desire for 'recognition.'"[1] History is violent because the self-conscious subject becomes inevitably involved in the fight for recognition that places it in opposition to nature and the existing social order. The subject transforms nature through work and the existing social order through revolutions and wars. At the end of history, all subjects become equally recognized in the framework of the "universal and homogeneous state" and return to their natural needs and desires. In this post-historical state, man ceases to be a subject opposed to nature and social order. But what is the role of beauty in the historical/post-historical context?

At first glance, it seems that for Kojève art is not opposed to nature insofar as art is not produced but "born." Kojève writes: "In fact, 'to be born' from someone does not mean 'to be born from a subject or subjectively,' and that which is 'born' from another is not for that reason subjective. Is the tree 'subjective' in being born from the seed produced by another tree? Is the act of fathering a

child a 'subjective' act? Is it necessary to say that the Universe is 'subjective,' that it is the result of a 'subjective' act, if one admits that it was created by God? Of course not. It is the same with a 'total' tableau, a tableau by Kandinsky."[2] God is not a "subject" because he is not opposed to an object or another subject. A painting is also not opposed to another painting or to any other object in the world if it is "nonrepresentational," that is, if it does not propose its own interpretation of the world that could contradict other interpretations by other paintings. It is in this sense that a nonrepresentational tableau by Kandinsky is not subjective but "total."

Where Kojève writes about an artwork as an autonomous entity, his text recalls the constructivist theories of art that were circulating when Kojève lived in Russian Berlin. The notion of an artwork as a thing was popularized in Germany by the magazine *Weschtsch – Gegenstand – Objet*, published in Berlin in 1922 (in three languages: Russian, German, and French) by Ilya Ehrenburg and El Lissitzky. As an example of a tableau—a painting as an autonomous thing—Kojève uses the monochrome painting. He writes: "Note that a white plane, or a black one, or one covered in a uniform color, exists as a plane without depth only insofar as it is considered as a tableau. Without doubt, it can be so considered: a uniformly black sheet *is* a tableau, and only man can make a uniform black sheet, nature having made nothing uniform. A museum consisting exclusively of sheets covered in different uniform colors would be, without a doubt, a mu-

seum of *paintings*: and each of these paintings would be beautiful—and even *absolutely beautiful*—independent of whether or not it was 'pretty,' which is to say, 'pleasing' to some and 'displeasing' to others."[3]

Here we have to contend with a brilliant curatorial project. But even more interesting is the fact that monochrome painting was rarely produced, exhibited, and discussed at that time. The exceptions are three monochrome paintings by Alexander Rodchenko—blue, yellow, and red—presented at the exhibition $5 \times 5 = 25$ (Moscow, 1921) and discussed by Nikolai Tarabukin in his book *From the Easel to the Machine* (1923)—a key text of Russian constructivism. Rodchenko's monochrome paintings were proclaimed by Tarabukin to be the "last paintings," which, by turning an individual painting into an object, end the history of painting.[4] According to Tarabukin, the next step could be only the production of utilitarian things. This idea of the "end of the history of painting" could be appealing to Kojève. In his essay, Kojève stresses that the monochrome painting is man-made and cannot be produced by nature—it is a purely artistic form that has its place in a museum, maintained alongside historically recognized works of art.

However, Kojève does not follow Tarabukin and the other constructivist theoreticians and artists who required "post-historical" art to produce utilitarian, functional things that demonstrate their functionality as beautiful. Indeed, Kojève asserts that even if a functional thing is beautiful, its beauty exists independently of its

function. As an illustration, Kojève uses, ironically, not a machine but a woman's breast. "A woman's breast can be *beautiful* (even without being 'pretty' or 'pleasing'). In this case, we attribute a value to the simple fact of its *being*, independent of its belonging completely to the body and to the universe, independent also of its 'utility,' of the fact that it can, for example, appease the hunger of an infant or the sexual desire of a man."[5] Thus, even if a woman's breast is a naturally produced object, its value as a pure form should be attributed to it independently from "body and universe." Here it is easy to see a certain ambivalence in Kojève's understanding of the relationship between art and nature. On the one hand, Kojève speaks about the artwork as naturally born, but on the other hand, he grounds its right to exist in a historical recognition of the artwork as beautiful. Of course, one could assume that Kojève sees art as anticipation of the post-historical return to nature. We will see that this is not the case, but first let us consider Kandinsky's understanding of the relationship between art and nature.

At the beginning of his book *Concerning the Spiritual in Art* (1912), Kandinsky claims that the representation of external reality leaves us cold as viewers. He describes a typical exhibition of the time: "Animals in sunlight or shadow, drinking, standing in water, lying on the grass; near to, a Crucifixion by a painter who does not believe in Christ; flowers; human figures sitting, standing, walking; often they are naked; many naked women, seen foreshortened from behind; apples and silver dishes.... The

vulgar herd stroll through the rooms and pronounce the pictures 'nice' or 'splendid.' Those who could speak have said nothing, those who could hear have heard nothing. This condition of art is called 'art for art's sake.'[6] This description shows clearly that what Kandinsky found irritating about naturalist painting was its formalism. When the motif is dictated from outside, all that matters is how it is executed—the formal skill of the artist. Or, if one wants, the beauty of the painting. Kandinsky opposes this formalist vision of art: only when one has defined what art is can one inquire about the how.

Famously, Kandinsky proclaims "inner necessity" to be the criterion for evaluating art. The greatest misconception regarding the notion of inner necessity is that it is often understood in expressionist terms, as an inner urge supposedly compelling the artist to paint this picture and not another. The most important aspect of the argument is thus overlooked: for Kandinsky, the emotions and moods reside not in the person but in the painting. The emotions communicated by the artwork are natural. However, the artist is a specialist in the communication of emotions—and is, in this sense, a self-conscious subject.

Before deciding to become a painter, Kandinsky studied law. So he knew only too well that communication obeys rules of its own, and it was the rules of art, understood as a visual rhetoric, that Kandinsky sought to reveal through his own art and his writing. All of Kandinsky's paintings can be understood as teaching materials, as

examples of how visual rhetoric works. This is also the significance of the greater part of his first book, which analyzes the psychological effects of colors and forms. It is obvious that when Kandinsky speaks about spirit, he actually means the unconscious: colors and forms influence the spectator in an unconscious way even if they remain overlooked when the spectator concentrates on the objects represented by a painting. Thus, as far as the artist controls the "language of form and color," he is also able to control the soul of the spectator and the whole "spiritual atmosphere" of the society in which he lives. Kandinsky writes: "The artist is not only a king, as Peladan says, because he has great power, but also because he has great duties."[7]

Kandinsky's response to the new constructivist theories of art was not dissimilar from the strategy he had already developed in *Concerning the Spiritual in Art*, and in 1926 he wrote *Point and Line to Plane* as a critique of the new avant-garde dogmatism. Instead of accepting the geometrical constructions of the radical avant-garde as revealing their medium of support—be it a canvas or a utilitarian object—Kandinsky analyzes the geometrical lines and figures as vehicles that transport specific affects. For example, the point in all its forms—square, circle, etc.—is interpreted as an element removed from its usual context in writing, where it marks a moment of interruption, of silence in the middle of speech.[8] According to Kandinsky, this meaning remains the same when the point is placed on the "basic plane" of the picture

Fig. 3
Examples of point forms.

Examples of point forms in Wassily Kandinsky's *Point and Line to Plane*

and thus conveys a "useless, revolutionary state of affairs."[9] Therefore, *Black Square* (1915) by Malevich can be interpreted as a quotation of a point on a canvas—as a sign of interruption without any indication of what it is meant to interrupt. Kandinsky interprets the straight line as the manifestation of a constant force, whereas jagged and curved lines are "dramatic" because they give the impression of being influenced by a number of different forces.[10] Once again here, the principle of inner necessity prevails: the geometrical, constructivist forms allow, and at the same time require, the artist to convey specific constellations of forces and their corresponding affects. Kandinsky also undermines the claim that monochrome paintings present only the pure medium beyond any message. The basic plane of any individual painting has a specific form that is limited by two vertical and two horizontal lines that are "lyric." Moreover, the picture plane may have a shape that is dominated more by horizontal or vertical lines. Each of these configurations of the picture plane has a specific mood-generating effect.

In other words, for Kandinsky an artwork is not a thing that represents other things or demonstrates its own thingness. In this respect, Kandinsky's and Kojève's views on art coincide. But Kandinsky sees the reason for an artwork's existence in its ability to influence the psychological makeup of a potential spectator—and not merely in the recognition of its beauty. In this sense, for Kandinsky the artwork remains subjective—the result of

a subjective, ethical decision by the artist to produce certain moods and feelings in the psyche of the spectators.

Later, Kojève also establishes a link between art and subjectivity—even if he does it in a somewhat different way than Kandinsky. As we already know, according to Kojève, artwork is "maintained" because it is beautiful, which separates artwork from other worldly things. The beautiful tree dies at a certain point—as does everything that lives. The utilitarian object is discarded when it loses its function. The fact that they are beautiful does not save these things from disappearance because beauty is not the primary reason for their existence. But if an artwork has been recognized as beautiful and thus valuable, it is maintained and protected from disappearance. This is the point at which the subject comes back into play—not as a producer but as a protector and defender of the artwork.

After World War II, Kojève's appreciation for the post-historical mode of life went through a certain evolution that is reflected in the famous footnote to his *Introduction to the Reading of Hegel* concerning the post-historical condition.[11] In the first version of this note (written for the first edition of *Introduction* in 1946), Kojève assumes that the post-historical state of the future will remain stable because everyone's animal desires will be recognized. Thus, human beings will no longer be opposed to nature. In this sense, man will cease to be a subject. Kojève refers to Marx, who predicted that the historical "realm of necessity," which placed humanity

in opposition to nature and one class in opposition to another class, will be replaced by the "realm of freedom," which will open to humanity the possibility of enjoying "art, love, play, etc." in harmony with nature.[12]

However, in the later extension of his note, Kojève signals a protest against the return of humans to nature. He writes that "if Man becomes an animal again, his arts, his loves, and his play must also become purely 'natural' again. Hence it would have to be admitted that after the end of History, men would construct their edifices and works of art as birds build their nests and spiders spin their webs, would perform musical concerts after the fashion of frogs and cicadas…."[13] Here the post-historical return to nature means the disappearance of "beauty" as the only reason the things that we call artworks exist— only natural and utilitarian things would remain. Thus, the end of history would also be the end of art.

Kojève finds that this return of man to animality was already realized in the American way of life that not only the West but also Russia and China aspire to. The only alternative Kojève finds is Japanese culture, which, as he describes it, opposes nature in the name of pure form— and thus transcends the Hegelian end of history. "To remain human, Man must remain a 'Subject *opposed* to the Object,' even if 'Action negating the given and Error' disappears"—even if the Hegelian-Marxian end of history is reached. The opposition between form and content leads humanity further than historical fights: "Post-historical Man must continue to *detach* 'form'

from 'content,' doing so no longer in order actively to transform the latter, but so that he may *oppose* himself as a pure 'form' to himself and to others taken as 'content' of any sort."[14] That is why Kojève connected hope for the re-humanization of humanity to a desire for the "Japanization" of the post-historical world.

It is obvious that Japan is not the first place Kojève discovered the practice of opposing form to content. The much earlier example is Kandinsky's artistic practice, which Kojève describes in a similar way. Kojève's turn back to belief in salvation through the pure, autonomous form is reminiscent of Kandinsky's description of the pre-condition for the same belief in *Concerning the Spiritual in Art*: "This cry 'art for art's sake' is really the best ideal such an age can attain to. It is an unconscious protest against materialism, against the demand that everything should have a use and practical value. It is further proof of the indestructibility of art and of the human soul."[15] Thus, even if the higher power and higher purpose become unachievable, art offers a way to resist reality—if not to overcome or transform it. In this regard, the uncle and the nephew find themselves in agreement.

1 Alexandre Kojève, *Introduction to the Reading of Hegel* (Ithaca, NY: Cornell University Press, 1980), pp. 6–7.

2 Alexandre Kojève, "The Concrete Paintings of Kandinsky," in Lisa Florman, *Concerning the Spiritual and the Concrete in Kandinsky's Art* (Stanford, CA: Stanford University Press, 2014), p. 165. See pp. 54–55 in this volume.

3 Kojève, "The Concrete Paintings of Kandinsky," pp. 154–155. See p. 34 in this volume.

4 Nikolai Tarabukin, *From the Easel to the Machine*, in *Modern Art and Modernism: A Critical Anthology*, ed. Francis Frascina and Charles Harrison (London: Harper & Row, 1983), pp. 135–142.

5 Kojève, "The Concrete Paintings of Kandinsky," p. 155. See p. 35 in this volume.

6 Wassily Kandinsky, *Concerning the Spiritual in Art* (London: Tate, 2006), pp. 9–10.

7 Kandinsky, *Concerning the Spiritual in Art*, p. 108.

8 Wassily Kandinsky, *Point and Line to Plane* (New York: Solomon R. Guggenheim Foundation, 1947), p. 25f.

9 Kandinsky, *Point and Line to Plane*, p. 28.

10 Kandinsky, *Point and Line to Plane*, pp. 68–69.

11 Kojève, *Introduction to the Reading of Hegel*, pp. 158–162.

12 Kojève, *Introduction to the Reading of Hegel*, p. 158.

13 Kojève, *Introduction to the Reading of Hegel*, p. 159.

14 Kojève, *Introduction to the Reading of Hegel*, p. 162.

15 Kandinsky, *Concerning the Spiritual in Art*, p. 106.

The Concrete Paintings of Kandinsky

I have tried to stay as close as possible to Kojève's original prose, even retaining his often odd (some might even say excessive) punctuation. Where he capitalized a letter, I have capitalized it; where he employed italics, I have followed suit. If he used a particular word or phrasing consistently—*le Beau*, for example—I have tended to do likewise, even when it produces rather strained locutions on the order of "one and the same Beautiful."

Where the word in question has clear Hegelian connotations, I have generally used the standard English translation of that term (e.g., "concrete" for *concret* or "absolute" for *absolut*). The one exception is the verb *maintenir* (or *se maintenir*)—*erhalten* and *sich erhalten* in German—which I have most often rendered, following translations of both Hegel and Kojève's *Introduction à la lecture de Hegel*, simply as "to maintain" and "to maintain itself." Occasionally I have translated it otherwise— as "to be preserved," "sustained," or "upheld," depending on the context. The term refers to something that is held—or, better, holds itself—together by means of its immanent constitution. As Kojève employs it, it carries connotations of "composition" (or, closer still, of the German *Zusammenhang*), yet it also suggests the kind of articulated relation of part to whole characteristic of organic (and other self-sustaining) systems. As the term appears in "Les Peintures concrètes de Kandinsky," it is closely associated with both the tableau (as distinct from the painting [*la peinture*]—an all-important distinction

I have also purposefully preserved in the translation) and the Beautiful: tableaux exist essentially to uphold or maintain the Beautiful, and any tableau able to maintain itself (i.e., to hold itself together in this way, by itself) is absolutely beautiful.

Lisa Florman

THE CONCRETE PAINTINGS OF KANDINSKY

ART

Undoubtedly there is a relationship between art and beauty.

However, they are clearly not the same thing. Even setting aside the "pretty"—(everywhere—and in art the "ugly" and the "pretty" can be beautiful or not-beautiful) there is the Beautiful in Art: a piece of music, a painting, a building, poetry ... and the Beautiful in that which is not Art: a plant, a human body, a birdsong, a machine, etc.[2]

The Beautiful that is specified in being incarnated in the tree is the beauty of the tree, of trees, of this tree; in a locomotive it is the beauty of the locomotive; in a painting [*tableau*] it is the beauty of the painting. But in all these specifications, two types are confronted: the Beautiful in Art or of Art and the Beautiful in non-Art or of non-Art. The two Beautifuls are the same Beautiful. However the Beautiful-in-Art is not the Beautiful-in-non-Art. How and why?

One and the same Beautiful is incarnated in the real tree and the painted tree.[3] But the incarnation of the

Beautiful in the real tree—that is to say, the beauty of this tree, the Beautiful in the tree or of the tree—differs from the Beautiful in the painted tree. The real tree is "in the first place" a tree; it is only following—"in the second place"—that it is beautiful, that it is an incarnation of the Beautiful. The real tree is "in the first place" thing, plant, giver of shade to the stroller, furnisher of wood to the carpenter, etc., etc. And it is only "subsequently" beautiful: for the "aesthete" who contemplates it, for the painter who paints it. The real tree is beautiful "in addition," "also," and it remains a tree even if it is not beautiful or ceases to be beautiful. Things are completely different with the painted tree, the painting "Tree." It is not a thing; it is not a plant. It shelters no one and serves no one. It *is* not and is of no usefulness. And in *being* not, it is not a beautiful tree; it is the Beautiful as tree. Or better still: it is not beautiful "also" and "in addition": it is only beautiful—or nothing at all. The painting [*tableau*] "Tree" is beautiful and beautiful only or it is not a tableau, but merely some colors on a surface.[4]

The painter who paints a beautiful tree does not paint the tree, but the beauty of the tree, the Beautiful in the tree or as tree: he neglects everything in the tree except its beauty, that is to say the Beautiful in it, and if he is not able to represent the Beautiful of the tree, he is not able to *paint* the tree, to make a *tableau*: he only dirties (colors) a surface.

Art is thus the art of extracting the Beautiful from its concrete incarnation, from this "other thing," which

is—"also"—beautiful, and of preserving it [*et de le maintenir*] in its purity. In order to preserve it, art also *incarnates* the Beautiful, in a painting [*tableau*] for example. But the tableau is beautiful "first and foremost" and it is only "also" and "subsequently" that it is canvas, colors, etc.... If it is not beautiful, it is *nothing*: good for nothing, good for being destroyed; the real tree is a *tree* which is "also" beautiful and which can *be* without being *beautiful*; the painted tree is the *Beautiful* that is tree or—if you prefer—the tree that is only beautiful and nothing else, that is *nothing* outside of its beauty. The beautiful in the real tree is the ornament of that tree; the beautiful in the painted tree is its very being, the painted tree being *nothing* [*néant*] without its beauty, outside of its beauty.

Thus: the Beautiful-in-non-Art is the beauty of a *being*, the Beautiful in being; the Beautiful-in-Art is the *being* of beauty itself, the Beautiful existing as such, the Beautiful being "in and for itself."[5] Art is the art of preserving [*de maintenir*] this Beautiful "in and for itself" by incarnating it in a being—painting, statue, music, poetry, etc.—which *is* only insofar as it is *beautiful*, the incarnation of the *Beautiful*. Specifically, Art is the art of "extracting" the Beautiful from the being (real, useful, etc.) that is "also" beautiful and incarnating it: the Beautiful in a being that is *only* beautiful, without then adding to the "extracted" and "incarnated" Beautiful something that, in being real, useful, or otherwise, would not be beautiful. For one cannot say that the painter, for example, "adds" to the Beautiful the oil and the canvas of his painting [*tableau*]: the

oil and the canvas are not the tableau, and the tableau is only the "incarnation" of the Beautiful and nothing else. What is this Beautiful that Art "extracts" from the beautiful thing by "incarnating" it in its pure state, in making of it a Beautiful-thing? It is a "value"—without any doubt. And—also without any doubt—a "useless" and "unreal" value. Useless, because it serves no purpose and is not made to serve. "Unreal" because it "does" nothing; it would not weigh down the pan of a scale, would not alter the needle of a galvanometer, would not stop a projectile . . . ; it would do nothing to avoid a blow, but the blow would be able to do nothing to it.

Being a value, the Beautiful is. It is without serving another thing, without being served by another thing, without being able to create or destroy anything other than itself, without being able to be created or destroyed by something other than itself. If, then, this value is a *value*, it is simply because it is what it is, *in* itself only, for itself only, and *by* itself only.

Thus: the Beautiful is a value simply because it *is*. And everything that has a value *solely* on account of the simple fact of its being is beautiful, is the Beautiful, is the Beautiful that *is*, the incarnation of the Beautiful. One makes something Beautiful—in and through Art—solely in order to make something Beautiful, that is, solely because of the simple fact that the *being* of the Beautiful has a *value*. And everything that one makes for the sole reason of its *being*, is made of the *Beautiful*, and made for *Art*.

This is the reason one makes a painting [*tableau*], for

example. One makes it *solely* so that it might *be*. And that is why it is necessary to make it beautiful. If [it is] not, it has no reason *for being*. And, having no reason to be, it is not: it is not a *tableau*, but a dirtied surface, which is there only to be destroyed (or in the future, unnoticed, to be consigned to artistic oblivion).

The Beautiful is being that has a value on account of the simple fact of its being, in itself, for itself, by itself. In order to be beautiful, being must then be able to be, that is, to be sustained [*se maintenir*], in-for-and-by-itself. In being sustained thus, it is beautiful, and it is only in being sustained thus that it is beautiful. The real tree is sustained by itself, by its immanent constitution, by the relationship of its parts; but it is sustained also by the ground that supports it, by the salts, water, and rays of the sun that nourish it, that is, by things *other* than itself; it is sustained in itself in its branches, its trunk, its roots, etc., but it is sustained also in the universe, which is something *other* than itself; it is sustained for itself, but it is so sustained for the birds that it shelters, for the man that it serves, that is, for things *other* than itself. That is why it is beautiful only "also" and "secondarily"— it is beautiful only insofar as it is sustained in-by-and-for-*itself*; insofar as it is sustained in-for-and-by-something *other* than itself, it is not beautiful; but this is precisely why it can be sustained even without being beautiful, independently of its being-beautiful. The painted tree, by contrast, is sustained only by its being-beautiful: the tableau "Tree" must thus be sustained solely in-by-and-

for-*itself*; the tableau is sustained only in the tableau, not outside of its "frame," and it is not in the universe of real things (there, it exists not as a tableau, but only as canvas, oil, etc.); the tableau is sustained only for the tableau, because it is there—as a tableau—only for those who can transpose themselves in *it*, see it "like an artist," that is to say, live—for as long as the artistic contemplation lasts—in it, for it, and by it. The tableau is sustained as a tableau only by itself, by the equilibrium of its parts, by the immanent laws of its interior life, nourished by nothing, save itself.

In summation: the Beautiful is that which is sustained solely in-by-and-for-itself, and all that is sustained in this way is beautiful. Art is the art of creating beings that are sustained in this way, and that are sustained only in this way. Specifically, Art can be [described as] the art of extracting from a being everything in it capable of being sustained in-by-and-for-itself, and of making from it something that is sustained solely in-by-and-for-itself.

PAINTING

We have spoken of Art while making use of the example of painting. Let us now speak of painting while making use of what we have said about Art.

Each of the senses has its art. Painting is the Art of the sense of sight. One sees space and surface. The Art of the sight of space or of a form enclosed by Space is sculpture. The art of the sight of space or of a form enclosed in Space is architecture.

(This is why one sees only the space closed by the sur-face of the statue, whereas one can also see the space en-closed within the surface of a building: one does not en-ter a statue.) The Art of the sight of the surface is painting.

The statue is a space closed by the surface. The tab-leau is *only* surface. That is why the tableau is essentially *flat*. Not the canvas (which can be concave or convex, etc.), but the tableau as tableau.

Generally, the tableau "represents" a space, that is, a statue (living or not) or a building (artificial or nat-ural). In it, then, there is "perspective," depth. But the *maintenance* [*maintien*] of the tableau, which is to say the *beauty* of the tableau, which is to say the tableau as *tab-leau* or work of art, does not depend on this "depth" that it "represents." The law of its maintenance is realized in two dimensions only: it is in the plane [*plan*] and only in the plane that the balance affecting its maintenance or, rather, that *is* its maintenance—which is to say its beauty, its artistic value—is brought about: the balance of forms and colors.

The beauty of the tableau is thus the beauty of the single surface, that is, of what remains of the beauty of a body if one suppresses its extension in depth. If nothing remains, the body cannot be *painted*, even while it could be sculpted, for example. The Art of painting is, there-fore, the art of making a surface that has a reason for be-ing in-by-and-for-itself, which has a value solely because it *is* and [which] can be sustained [*se maintenir*] without needing the existence of something external to it. Clearly

it is only the *tableau* that can exist wholly on such a pure, flat surface, for the canvas necessarily has depth.[6] Note that a white plane, or a black one, or one covered in a uniform color, exists as a plane without depth only insofar as it is considered as a tableau. Without doubt, it can be so considered: a uniformly black sheet *is* a tableau, and only man can make a uniform black sheet, nature having made nothing uniform. A museum consisting exclusively of sheets covered in different uniform colors would be, without a doubt, a museum of *paintings* [*peintures*]: and each of these paintings would be beautiful—and even *absolutely beautiful*—independent of whether or not it was "pretty," which is to say, "pleasing" to some and "displeasing" to others.

But uniform coloration does not exhaust the Art of painting. One again has tableaux if one divides the uniform surface with strokes of another uniform color, these strokes serving only to divide the surface: such tableaux are called *drawings*. And one also has tableaux if one inserts into a uniform surface other uniform surfaces of different colors (which can be of any dimensions whatsoever and can completely cover the original surface): these tableaux are called *paintings*. One can also make *colored drawings*, if one accentuates the division of the uniform surface by assigning different colors to the different parts of the divided surface (i.e., of the drawing). Finally, one can make a *drawn painting* if the inserted surfaces are surfaces of a single color, different only in the intensity of that color.[7]

These four types exhaust the possibilities of painting. But the possibilities of these four types are practically infinite.

Still, there will be—in all of these types—*tableaux*, which is to say works of Art or instances of pure incarnated Beauty only if the manufactured flat surface manages to be sustained [*se maintenir*] in-by-and-for-itself, thus having a *value* by the simple fact of its *being*.[8] The man who makes a beautiful flat surface is a painter who has made a tableau: the one who has not succeeded in doing that has only managed to dirty a bit of paper or some other thing.

In order to explain the beauty of the surface of a body, that is to say, of its visual aspect, which, being closed to the body in *three* dimensions, is independent of its extension in depth—in other words, in order to explain a *tableau*—we will use an example borrowed from the domain of the nonartistic Beautiful.[9]

A woman's breast can be *beautiful* (even without being "pretty" or "pleasing"). In this case, we attribute a value to the simple fact of its *being*, independent of its belonging completely to the body and to the universe, independent also of its "utility," of the fact that it can, for example, appease the hunger of an infant or the sexual desire of a man. But the Beautiful incarnated in this breast—taken as the *visual* Beautiful—can be revealed in its three aspects of the architectural, the sculptural, and the pictorial Beautiful.

The architectural aspect, that is, the beautiful of the

space contained by the surface, cannot—it is true—be *seen* in the proper sense of the term (one cannot *enter* to see the interior). But touch here can play the role of sight: the hand can transmit to us the Beautiful of the space limited by its skin. (The Beautiful in question here—and which the hand transmits to us—is not that of touch, but something completely different; it is the Beautiful of the geometric *form* of *solid [plein]* space become beautiful because it is a breast.) As for sight itself, it reveals to us above all the sculptural Beautiful, that is, the form contained in the surrounding space, form in the everyday sense of the term, which—although three-dimensional—does not evoke the *interior*, covered and forever hidden by the surface. In short, vision will make us see the Beautiful of the surface itself, that is to say, the beautiful of the *skin* of the breast or, more exactly, of its visual aspect. The Beautiful is incarnated in the skin, which follows the form of the breast. But *this* Beautiful is absolutely independent of that form, which is why it can be preserved as such [*être maintenu tel quel*] in being incarnated in a *flat* surface. And it is only this *flat* visual surface of the skin that is a *pictorial* value.

The painter who paints the Beautiful of the breast extracts what exists in-by-and-for-itself [*extrait le maintien en-par-et-pour-soi*] from the composing *planes* of the visual aspect, and from them *alone*. His painting can certainly also "reproduce" the *form* of the breast, but—in doing so—it will have no *pictorial* value. The painting can reproduce the sculpture and architecture of the

breast, and this reproduction *cannot* harm its pictorial value. But if the painting does nothing but reproduce the sculpture and the architecture, it will not be a *tableau*: it will be a "photograph," that is, a reproduction without proper artistic value, of a "sculpture" (colored or not) or of an architecture reproducing (artistically or not) the sculptural and the architectural *Beautiful* of the breast: the pictorial Beautiful will remain un-"reproduced." And in this case it would be better to employ a sculptor (who can, if he wants, color his statue) without making a tableau at all. (This is why a painter will relinquish to the sculptor the model with breasts of impeccable form but skin that does not embody the Beautiful.)

In sum: the Art of painting is the art of creating—or of extracting from the real—two-dimensional visual aspects that are sustained [*se maintiennent*] in-by-and-for-themselves and that, as a result, *are* solely because they have a *value*, and have a *value* solely because they *are*.

ABSTRACT AND SUBJECTIVE PAINTINGS

We just said: "create or extract." In other words, we have distinguished two fundamental types of the Art of painting. Let's attempt to distinguish between them by beginning with the latter, with the art of *extracting* the pictorial Beautiful from the *non*artistic real.

This is the Art of painting in the standard sense of the term, such as it was practiced everywhere and always, since the beginning until the appearance of the first painting that was not a "representation" of the nonartistic

real, of a thing, a plant, an animal, a human being, etc. And it is practiced still alongside the Art of "nonrepresentational" painting, of which we will speak later.

We will define "representational" painting by saying that it is an *abstract* and *subjective* painting. Here is why.

This painting is *abstract* above all in the sense that the Beautiful it embodies is "extracted," which is to say "abstracted," from the nonartistic real.

The Beautiful embodied by the tableau "representing" a beautiful tree is in-by-and-for-itself. But this Beautiful was not *created* as such by the painter. He himself "extracted" or "abstracted" it from the beautiful tree: before being in the tableau it was in the real tree. Because of its origin, then, the Beautiful of the "representational" painting is an *abstract* Beautiful. Thus, for example, the Beautiful of the tableau "Tree" was abstracted from the real tree, or rather this Beautiful was already real before being realized in and by the tableau; in this way, as far as its origin is concerned, the Beautiful of the tableau is "less" real than the Beautiful of the tree, which is to say more abstract than it. The attitude of the painter who "paints" the tree is analogous to that of the botanist who describes it in his book: the pictorial and verbal "representations" are less real—that is to say, more abstract— than is the tree [being] represented.

It follows that, being "abstract" in and through its origin, the Beautiful of the "representational" painting is also "abstract" in its very being.

In order to see this, let's take the example of the real

tree and the painted tree. Rough [to the touch], the real tree is "primarily" a tree and beautiful only "after that" and "also," whereas the painted tree is "primarily" *beautiful*, and it is *nothing* "after that." The Beautiful incarnated in the real tree is thus essentially attached to the *reality* of the tree, whereas the beautiful of the painted tree is essentially *detached*. The Beautiful-of-the-real-tree, while being—insofar as beautiful—in-by-and-for-itself, is not *only* in-by-and-for-itself, but still in-by-and-for the *tree*, which is *not* in-by-and-for-itself, whereas the Beautiful-of-the-painted-tree is in-by-and-for-itself only: the second is therefore—in its very being—less real, that is, more abstract, than the first.

In fact, the real tree is large, it has a thickness, it is heavy and rough, its branches can be moved under the pressure of the wind, it has a smell peculiar to it, its leaves can make sounds, and so on, almost to infinity. There is none of that in the painted tree: the painted tree is only the flat visual *aspect* of the real tree, and even if—drawn in perspective—it renders the visual *aspect* of the latter's real depth, it does not itself have real depth in reality. Now, the Beautiful-of-the-real-tree is not only in the Beautiful of the flat visual aspect of this tree but also the Beautiful of the entire concrete, real tree: the Beautiful of the tree is also the Beautiful of its depth, of its sounds, of its smell, of its rough trunk, etc. Just like the tree itself, the Beautiful-of-the-tree is a Beautiful in three dimensions: tall, wide, and deep. The Beautiful-of-the-painted-tree, by contrast, is only the Beautiful of

the *flat* surface of the tableau. Besides, the tree does not exist in a vacuum: it is on earth, under a sky, etc., etc.—in short, it is part of the *Universe*, and it cannot be isolated from this universe, from the concrete world of real things. Accordingly, the Beautiful-of-the-real-tree is also a non-isolated Beautiful, not withdrawn into itself, but a Beautiful inserted into the Beautiful of the Universe and, above all, into the Beautiful of the "landscape" of which it is a part. The Beautiful-of-the-painted-tree, by contrast, is inserted only into the part of the flat visual aspect of the surrounding landscape that is "represented" in the tableau, within the limits of its "frame."

Thus, the Beautiful-of-the-painted-tree is much *poorer* than the Beautiful-of-the-real-tree: everything there is suppressed, one has made an *abstraction* of everything, except the flat visual aspect, and there again only a fragment is preserved [*on n'en maintient qu'un fragment*].

In order to avoid all possible misunderstandings, let us say here and now that the *limited, flat* surface of the tableau *can* incarnate a Beautiful that is concrete, complete, withdrawn into itself, [and] self-sufficient. [But] the Beautiful incarnated in the flat, limited surface of the tableau "Tree" is an *abstract* Beautiful, that is to say, one incomplete and unreal, *solely* because the Beautiful of the tableau is a Beautiful-of-the-tree, because this Beautiful is the Beautiful of a tableau that "represents" a tree. In wanting to paint the Beautiful of a *tree*, one is inevitably led to suppress certain interesting elements of that

Beautiful, to "extract" from them, that is, to "abstract" from them the visual aspect alone, to reduce this aspect to a planar state, which is to say, to make an abstraction of depth and—in general—of everything that is not offered to sight directed from a fixed [vantage] point, and to cut into that flat aspect an area limited by the straight or curved lines of the "frame," i.e., to make again a—final—*abstraction*. And if the concrete Beautiful of the real tree is *real*, sufficient unto itself, the abstract Beautiful of the painted tree is not; in order to be *real*, it needs all of its constituent elements; yet only some of them have been retained.

Obviously, it is the same in all "representational" paintings, that is, in every tableau that incarnates a Beautiful already existing outside of the tableau [and] before the tableau, without the tableau—in a real, nonartistic object. As soon as the pictorial Beautiful must "represent" a Beautiful that is not only and uniquely pictorial, the pictorial Beautiful is poorer and less real than the Beautiful "represented": said otherwise, it is an *abstract* Beautiful.

The Art of "representational" painting is in the art of *abstracting* the pictorial component of the full Beautiful incarnated in the nonartistic real, and of presenting [*de mantenir*] that abstract Beautiful in—or as—the tableau. The "representational" painting is a painting of the abstract Beautiful: it is an *essentially abstract* painting.

Now, being *abstract*, this painting is necessarily *subjective*.

It is that—above all—in and because of its origin. For, if this painting "extracts" something from something, it is necessary that someone—a subject—made this extraction; if this painting carries out an "abstraction," it is necessary that this abstraction is carried out in and by a "subject." The concrete Beautiful of nonartistic reality passes through this "subject"—the painter—before being incarnated, as the abstract Beautiful, in the tableau. The Beautiful of the tableau is thus a Beautiful transmitted by the subject—a Beautiful subjectivized in and by this transmission, it is a *subjective* Beautiful.[10]

Let's take again the example of the tree. The painter paints it just as he *sees* it from the location where he finds himself: it is he who makes the choice of aspect, he who chooses what he wants to abstract from the total Beautiful of the tree in order to paint it. But the intervention of the subject is not exhausted in the choice of visual perspective. Having made that choice, the painter, unable ever to "represent" the totality of the Beautiful, will again have to make an abstraction of certain constitutive elements of this aspect of it, and it is again *he* who must do it. In short, the painter of the "representational" painting can paint only the Beautiful of the *impression* that the thing to be "represented" produces in *him*: "representational" painting is always more or less "impressionist," that is to say, subjectivist, subjective.

But that still is not all. The tree is not exclusively in-by-and-for-itself: it is also for another thing, notably for man, thus also for the painter insofar as he is a man: it "pleases"

or displeases him, arouses in him—in a general manner—various feelings, is "useful" to him or not, etc., and so on. All of this applies to any nonartistic object whatsoever, and it applies to a nude body, a deity, an historic event, etc., even more than it does to the tree. The Beautiful of the nonartistic object is also the Beautiful of all that the object is used for, of everything that it evokes in other things. In other words, the painter always has an "attitude" toward the object to be painted, and the revelation of the Beautiful in the object is also affected in and on account of these "attitudes." Certainly the painter can make an "abstraction" of these attitudes, that is to say, of the aspects of the complete Beautiful revealed by them. But, first of all, if he does that, he simply takes—in making it—a particular attitude, that of "disinterest"—which is also *his*; and, secondly, it is very rare that he makes that abstraction completely. He generally maintains one or several of his "attitudes," and paints, in addition to the Beautiful of the object, the Beautiful of the *attitude* that he takes toward the painted object; he *expresses* the Beautiful in this personal attitude, so that his tableau is always more or less "expressionist," and thus—again—subjective.

Everything that can be said of the *origin* of the Beautiful of the representational painting must be said as well of its very *being*: having an *origin* that is subjective or subjectivist ("impressionist" or "expressionist"), it *is* subjectivist or subjective ("impressionist" or "expressionist").

In effect, the Beautiful of the painting "Tree" must be the Beautiful-of-the-tree. Now, the Beautiful of the

painting is not the Beautiful of the tree but only a "fragment" of this Beautiful. (For example: a pencil drawing neglects the color of the tree, etc.) It is therefore a Beautiful *other* than the Beautiful of the tree. If it is nevertheless a Beautiful-of-the-*tree*, it is yet necessary to add to it the elements that it *lacks*, those that the painter abstracted, which are not in the painting. Obviously, it is only a *subject* who can add them, and he can add them only himself, out of the *impression* that the painting made on him. In short—it is the spectator who must add them, and in order to be able to do that he must be familiar with real trees and recognize that it is a real tree that is "represented" by the tableau. The "representational" painting must therefore always be subjectively completed by the spectator in order really to be what it is supposed to be: a painting that "represents" the Beautiful of a real nonartistic object. The being of the Beautiful-of-the-"representational"-painting is not, then, complete in itself: in order to be complete, which is to say, to *be* completely, it needs a contribution from the spectator, from a subject. The being of the Beautiful-of-the-"representational"-painting necessarily implies, therefore, a subjective constituent: it is *subjective* or subjectivist, and it is so because it is *abstract*.

Let's clarify, in order to avoid possible misunderstanding. In what was just said, we had in mind a subjective contribution that was purely pictorial. In fact, the contribution provided to the "representational" painting by the "subject" of the spectator is much richer than

that. In the first place, while contemplating the Beautiful of a "representational" painting, one generally adds the sculptural and architectural elements of the complete Beautiful of the object "represented," that is, of the elements that not only are not in the contemplated painting, but which have nothing to do with painting in general. In addition to that, however, one involuntarily adds even some essentially nonartistic elements, which are in the object "represented," but necessarily absent from the artistic representation of the object: one need think only of the erotic or even sexual element that one sometimes "adds" to a "nude." But even apart from these non-pictorial—indeed nonartistic—elements, the subjective contribution is necessary to the very *being* of the purely pictorial Beautiful of the "representational" painting: in order for the Beautiful of the painting to be able to "represent" the pictorial Beautiful of a real nonartistic object, it is necessary to add to it some purely pictorial elements that are in the object, but that are necessarily lacking in the painting.

Once again, then, representational painting is essentially abstract and subjective.

Nevertheless, one can distinguish *four types of "representational" painting*, each being more or less subjective and abstract than the others: "symbolic" paintings, "realist" paintings, "impressionist" paintings, and "expressionist" paintings.[11]

Expressionist paintings embody the pictorial Beautiful of the subjective "attitude" that produces in the

painter the nonartistic object that he wants to "represent." So, for example, in painting a tree, the painter paints not the pictorial Beautiful of the tree, but the pictorial Beautiful of the "attitude" that he himself takes vis-à-vis that tree. The expressionist painting is thus the most subjective of all possible paintings: it "represents" not the object but the subjective attitude provoked by the object. But this painting is also the least abstract of all: the painter "represents" the *totality* of the Beautiful of the "*attitude*" (precisely because it is his attitude), and there is abstraction only insofar as the attitude is conditioned by the Beautiful of a nonartistic object, this latter Beautiful being impossible—as we have already seen—to "represent" totally.

Impressionist paintings embody the Beautiful of the visual *impression* that the beautiful in the object makes on the painter. There is therefore less subjectivism than in the expressionist painting: if—in this case again—the painter paints less the object than himself, he is now absorbed by the object, whereas before it was the object that was absorbed by him. On the other hand, there is more abstraction in this painting: the painter's impression being produced by the object and by it alone, the Beautiful of the impression must be submitted to almost the same process of abstraction as was the object.

The *realist* painting embodies the Beautiful of the nonartistic object seen by the artist. Here, therefore, there is less subjectivity. It is not the Beautiful of the momentary impression that is painted, but the Beauti-

ful of the object, such as it is revealed to the artist's in-depth ocular study (the painting reproducing even the "unimpressive" elements, etc.). However, the subjective element always remains present, as it is always the aspect seen by the painter that is painted and nothing else. Of course, with the diminution of subjectivism, the degree of abstraction increases.

Finally, the *symbolic* painting: this is, for example, the painting called "primitive." Here, the Beautiful of the painting is not embodied in an accurate (or "realist") representation of the nonartistic object embodying the Beautiful to be painted: this object is "represented" symbolically or schematically. This signifies a new and final reduction of subjectivism: the schema refers neither to the personal "attitude" of the painter nor to the visual impression that the object produces in him, nor again to the visual aspect that the object presents to all those who see it, but to the object itself, independent of how it appears in concrete vision. (For example, no one sees a face [like those] "represented" in an Egyptian painting, where the eye is represented frontally and the nose in profile.)

The "schematic" painting "represents" the Beautiful of the seen *object*, and not the Beautiful of the *sight* of the object. The subjective element is thus reduced to its minimum. But it is still present since it is the *seen* object that is "represented," the scheme or symbol always being a combination of visual elements. And it goes without saying that the minimum of *subjectivism* is seconded by

a maximum of *abstraction*: the Beautiful of the symbolically "represented" object "represents" only a very small portion of the Beautiful of the real object "represented."

These four types exhaust the possibilities of "representational" painting. But, of course, these types are exact only in theory. In fact, there are symbolic, realist, impressionist, and expressionist elements in *every* "representational" painting: it is only a matter of more or less. One speaks of a "realist" painting if the three other elements are much less pronounced there than the realist element; and so on. It is also possible that two or three elements will be almost equally pronounced, giving the appearance of a new type of painting, without it being one in reality.

We cannot get distracted here by these questions of detail. We will say a few words only about the painting called "modern" or "Parisian," of which Picasso is the most typical and most important representative.

This is a painting in which the realist and impressionist elements are almost totally absent, and where the two others are about equally developed: it is an expressionist symbolism or a symbolic expressionism. That combination is carried out in such a way that this painting is at once the most *abstract* and the most *subjective* of all possible representational paintings: the *abstraction* of the objective symbol serves to "represent" the *subjectivism* of the painter's personal attitude. Consequently, at every step this painting runs the risk of completely annihilating itself in the void of absolute abstraction

and pure subjectivism, both of which fall outside the realm of painting and even of art in general. The *genesis* of such a tableau demands as a result an enormous effort ("genius") on the part of the painter, and its *maintenance* is possible only thanks to an effort just as considerable ("congeniality") on the part of the spectator. It is hardly surprising, as a result, that even a painter of Picasso's caliber succeeds in making a tableau only about once in every hundred times that he puts colors to canvas. And even less surprising is the fact that the vast majority of his admirers are absolutely incapable of distinguishing—within his oeuvre—the tableaux from the [merely] gaudy canvases.

But, once again, it is in the "representational" painting of our day that subjectivism and abstraction are pushed to their maximum, they are not—and cannot be—absent from any "representational" painting: every tableau that incarnates a Beautiful already incarnated first in a real, nonartistic object is necessarily and essentially an *abstract* and *subjective* tableau.

CONCRETE AND OBJECTIVE PAINTINGS
(THE ART OF KANDINSKY)[12]

For centuries, humanity knew how to produce only "representational"—that is, *subjective* and *abstract*—paintings. And it was only in the twentieth century in Europe that the first *objective* and *concrete* tableau was painted, that is, the first "nonrepresentational" tableau. The Art of "nonrepresentational" painting is the art of

embodying in and by a drawing, a colored drawing, a drawn painting, or a painting proper, a pictorial Beautiful that is not, has never, and never will be embodied anywhere else: in no real object other than the painting itself, which is to say, in no real, nonartistic object. This art can be called the art of Kandinsky, as Kandinsky was the first to paint (beginning in 1910) objective and concrete paintings.

Concrete first and foremost. Here is why:

Let's take as an example a drawing, in which Kandinsky incarnates a Beautiful involving a combination of a triangle with a circle. This Beautiful was not "extracted" or "abstracted" from a real, nonartistic object, which would be—"also"—beautiful, but—"primarily"—something else again. The Beautiful of the tableau "Circle-Triangle" exists nowhere outside of that tableau. Just as the tableau "represents" nothing external to it, its Beautiful is also purely immanent, it is the Beautiful of the tableau that exists only in the tableau. This Beautiful was *created* by the artist, just as was the circle-triangle that embodies it. The circle-triangle does not exist in the real, non-artistic world; it does not exist before, outside of, or apart from the tableau; it was created in and by—or as—the tableau. And it is only in and for this creation of the circle-triangle that the Beautiful incarnating it was created. That Beautiful too did not exist before the tableau, and it does not exist outside of it, independent of it.

Now, if the Beautiful was not *extracted* or *abstracted* but created whole cloth, it is—in its very *being*—not *ab-*

stract but *concrete*. Being created whole cloth, that is entirely, it is as whole: nothing is missing from it, nothing was removed from it, since this Beautiful—nonexistent outside of the tableau—cannot be richer and more real than it is in the tableau or as the tableau. The Beautiful is thus in the tableau in the full plenitude of its being, which is to say, it is there in all its concretion; the Beautiful of the tableau is a real and concrete Beautiful, the tableau is a real and concrete Beautiful; the real tableau is concrete.

In the case of the tree and the tableau "Tree," it is the tree that is real and concrete, whereas its "representation" in the painting, or the painting that "represents" it, is unreal and abstract. It is the same for the Beautiful of the tree and of the tableau. In the case of the circle-triangle, by contrast, there is only one circle-triangle, which is precisely the circle-triangle of the tableau or the tableau "Circle-Triangle" itself. The Beautiful of the tableau "Circle-Triangle" is therefore just as real and concrete as the Beautiful of the real and concrete tree: the tableau "Circle-Triangle"—and its Beautiful—are at the level of reality and concretion of the real tree, and not at the level of reality of the tableau "Tree," which only "represents" the tree and its Beautiful, being the abstraction of the tree and of the Beautiful of the tree.[13]

In a certain sense, the tableau "Circle-Triangle" is even more real and complete, which is to say, more concrete, than the real tree. In fact the tree is not uniquely in itself, for and by itself: it is on the earth, under the sky,

alongside other things, etc.; in short—it is in[,] by and for the Universe, the entire real world, and to extract it from this world is to transform it into an abstraction (just as, for example, the painter who "represents" it isolated on a white sheet or in a tableau that is inevitably *limited* does not include the *whole* Universe). By contrast, the circle-triangle is nothing except in itself, and it is no-where save in itself, that is to say, in the tableau "Circle-Triangle"; it is not *in* the Universe; it *is* a Universe, complete and unto itself; it is itself its own universe, and it is only through this universe, which it is, and for this universe, which is its own being. Said otherwise, the tableau "Circle-Triangle" does not "represent" a *fragment* of the Universe, but an entire universe. Or, more precisely, since this tableau "represents" nothing but only *is*, it *is* itself a complete universe. In that sense, it then is—and its Beautiful with it—more real and more complete, which is to say, more concrete, than the tree and the Beautiful that it embodies.

Each of Kandinsky's tableaux is a real, complete, and therefore concrete universe, self-contained and self-sufficient: a universe that, just like the nonartistic Universe, the uni-totality of real things, is only in itself, by itself, and for itself. One cannot say that these tableaux "represent" fragments of that nonartistic Universe. One can say at the very most that they *are* fragments of that Universe: Kandinsky's tableaux belong to the Universe in the same way as do trees, animals, rocks, men, States, clouds . . . , as does everything real that belongs to (is in)

the Universe while constituting this Universe. But where the *Beautiful* of Kandinsky's tableaux is concerned, it is more accurate to say that it is independent of the Beautiful of the Universe and of the Beautiful of the things that belong to this Universe: the Beautiful of each tableau by Kandinsky is the Beautiful of a complete universe, and these artistic Beautifuls come to stand alongside—in a sense—the unique and artistic Beautiful of the real Universe.

Each tableau by Kandinsky is thus a real and complete, that is, concrete universe, just as is the Beautiful of that tableau. And that is why Kandinsky's "nonrepresentational" painting can be called "total" or "uni-total" painting: [it is] the art of creating Universes whose being comes down to [*se réduit*] their Beautiful. This "total" painting stands in contrast, then, to "representational" painting, that is, to "symbolic," "realist," "impressionist," and "expressionist" paintings. But, just like the other paintings, this painting can be made in [any of] the four pictorial types of drawing, colored drawing, drawn painting, and painting proper.

Being essentially concrete and not abstract, "nonrepresentational" or "total" painting is necessarily *objective* and not subjective. It remains only for us to show that this is the case.

For one thing, "total" painting is not subjective in its origin. An abstraction can be performed only if a "subject" performs it: for abstraction signifies choice, and choice signifies a personal, which is to say, a subjective,

attitude: the tree—in its totality—(and without me) exists; but the particular aspect of the tree "represented" in the tableau is in me and exists only if I do. Now, the "total" tableau is not an abstraction: the circle-triangle is in it in its totality; it exists then without me, just as does the real tree. And if the circle-triangle is born, it is born like the tree is born from the seed; it is born without me; it is an objective birth; it is the birth of an object.

Admittedly, the tableau is "born" of the painter: Kandinsky's tableau "Circle-Triangle" would not exist without Kandinsky; Kandinsky is its "father." But this has nothing to do with "subjectivism" and the birth of a "representational" tableau. The "birth" of the tableau "Tree" is in some sense double: there is first the "birth" of the *abstraction* "Tree" and then the "birth" of the *tableau* "Tree," which incarnates that abstraction.[14] In the case of the tableau "Circle-Triangle," there is, by contrast, only this latter "birth," the first having no place, as the tableau is not abstract. Now, obviously, it is only the first "birth" that is subjective. No subjective element intervenes in the "birth" of the "total" tableau.

In fact, "to be born" from someone does not mean "to be born from a subject or subjectively," and that which is "born" from another is not for that reason subjective. Is the tree "subjective" in being born from the seed produced by another tree? Is the act of fathering a child a "subjective" act? Is it necessary to say that the Universe is "subjective," that it is the result of a "subjective" act, if one admits that it was created by God? Of course not. It is

the same with a "total" tableau, a tableau by Kandinsky.

Kandinsky is the "father" of his tableau "Circle-Triangle." But that painting is just as independent of him, just as objective—in its origin and in its being—as a son is objective and independent of his father. Kandinsky creates his tableaux—and the Beautiful in them—as a living being begets another, or rather—since he is "father" and "mother" at once—as Nature engenders beings, or better still—since he creates out of nothing—as God creates the Universe: in each of his tableaux he creates a concrete and objective universe, which is created *ex-nihilo*, since it did not exist before and was not extracted from anything, and which is complete in itself and unique, since it does not exist apart from itself.

Consequently, one should say not "Kandinsky's tableau" [*tableau de Kandinsky*] but "a tableau *by* [*par*] Kandinsky." And it would be better still to do away with the "Kandinsky" completely and to say simply "tableau." For if every "representational" tableau is a thing seen by . . . , in such a way that it is relevant to know *by whom* the thing is seen, that is, *whom* the tableau is *by*, the "total" tableau is the thing itself, and it is just as irrelevant to know who saw or sees that thing as it is to know if a real tree is seen by someone and by whom it is seen, if it is seen. If—for those who do not know Kandinsky personally—he is nothing without "his" tableaux, those tableaux are *everything* that they are *without* Kandinsky. His art is the art of the creation of the Beautiful, in the strong and proper sense of the term, and this creation, like all true

creation, is independent of the creator, of the *creating* subject. Now, being independent of the subjectivity of their creator, Kandinsky's tableaux are absolutely independent of everything that this subjectivity implies. In particular, these tableaux are as little "intellectual" as possible; if it is nonetheless necessary to use one's "intelligence" in order to "represent" a tree, one can engender a circle-triangle like Nature—which certainly does not think in engendering a being.[15]

Thus, in regard to their origin or genesis, the concrete tableaux of Kandinsky are objective. And they remain objective in their being.

Needing no subjective contribution during its "birth," the "total" tableau has no need for it during its "life" either: it *is*, or is maintained [*se maintient*], every bit as objectively as it is born, that is, it does not depend on the subjective contribution of the spectator, and that is why it can *be*, it has a reason *to be*, even if it is contemplated by no one. The Beautiful-of-the-painted-tree is not what it is supposed to be—a Beautiful-of-the-*tree*—as long as the spectator does not complete—subjectively—the abstraction of the painted-Beautiful, thereby bringing it closer to the real Beautiful: the tableau "Tree" thus needs the spectator in order to be what it is supposed to be, namely, a tableau that "represents" a tree (and this spectator must "know" that it is a tree, must have previously seen real trees, etc.). The Beautiful-of-the-circle-and-triangle, by contrast, *is* what it is supposed to be in and by itself, and it does not need anyone in order to be what

it is. It is what it is without the contribution provided by the "subject" of the spectator, and that is why the spectator does not need to be a "subject" while contemplating it: he can "forget himself" in the act, and the tableau will be for him what it is without him. Thus, he does not need to "know" that it is a circle or a triangle, he does not need to have seen them previously, etc. In short, the spectator plays the very same role in regard to a Kandinsky tableau that someone who sees a real object plays in regard to it.

Generally speaking, the "total" tableau, in not being the "representation" of an object, *is* itself an object. Kandinsky's tableaux are not paintings of objects but painted *objects*: they are objects in the same way that trees, mountains, chairs, States ... are "objects"; only they are pictorial objects, "objective" paintings. The "total" tableau *is* as objects *are*, that is, it *is* in an *absolute* and nonrelative way; it *is* independently of its *relations* with anything else; it *is*, like the Universe *is*. And that is why the "total" tableau is also an "absolute" tableau.[16]

In sum: in contrast to "representational" painting, which—in all of its four avatars of "symbolism," "realism," "impressionism," and "expressionism"—is abstract and subjective, Kandinsky's "nonrepresentational" or "total and absolute" paintings are concrete and objective: objective—because they neither imply nor demand any subjective contribution from either the painter or the person contemplating them; concrete—because they are not abstractions of anything existing outside of them, but are instead complete and real Universes

existing in-by-and-for-themselves in the same way that the real, nonartistic Universe does.

ADDENDA

1. One might well ask me why—in speaking of "non-representational" or "total and absolute," which is to say, of concrete and objective painting—I speak only of Kandinsky.

It is quite simply because, having seen very few intentionally "nonrepresentational" tableaux, it is only in the work of Kandinsky that I have found things which—in my opinion—are *tableaux*, which is to say, works of art.

I say: "in my opinion" because—at least so far—it is impossible to demonstrate rigorously the artistic value of a tableau. Can one prove that Rembrandt is "greater" than a Meissonier, for example, or that Monsieur X is not an artist? The purely subjective element is inevitable here, and that is why I allowed myself to mention Kandinsky, who is the only "nonrepresentational" artist that I know, without trying to familiarize myself with the others, all the others.

But in spite of the presence of a subjective element in artistic appreciation, certain judgments bearing on Art nonetheless have an objective and absolute value. Thus, for example, it is incontestable that Kandinsky is an artist: to deny it is simply to show a total incapacity to distinguish a painting [*tableau*] from a colored surface. Now, the simple fact of the existence of Kandinsky's tableaux

is enough to provide a basis for my argument concerning the essence of the painting that I call "absolute and total" and which I said is—in contrast to all the others—concrete and objective.

I discovered the "idea" of this painting while contemplating Kandinsky's tableaux, and it is thus completely natural that I lay out that idea while using his tableaux as examples and evidence.

Conversely, one could ask me why, in writing on Kandinsky, I write an article three-quarters of which has—on first glance—nothing to do with him.

It is because I believe one cannot say what must be said about Kandinsky without saying that his painting is not a painting akin to others, like one genre among several, but rather that it is opposed to all of those genres taken as a group.

Now, in order to be able to say—in section 4—that Kandinsky's painting is opposed, as "nonrepresentational" or "total and absolute," i.e., concrete and objective, to all painting that is "representational," "symbolic," "realist," "impressionist," or "expressionist," which is to say, subjective and abstract, I had to say what I said in the first three sections of my article, where—obviously—it was not a question of Kandinsky himself.

2. One might wonder how it happens that certain people declare themselves hostile not just to Kandinsky's painting—which is not an interesting problem—but also to "nonrepresentational" painting in general, to, as it were, the "idea" of that painting.

At first glance, it is incomprehensible. There is no longer anyone today who would seriously deny the right of the painting I call "realist" to exist, and who, for example, would argue that all painting must necessarily be "impressionist," say. Generally speaking, we are willing to recognize the equal right of existence of all four types of "representational" painting that I distinguished. And we protest only very rarely against the combination of those types: even against the combination that I mentioned under the name of "symbolic expressionism." In short, we recognize the right of any genre whatsoever of "representational" painting to exist, and we are undoubtedly right to do so.

Why then do we want to deny the right to exist to "nonrepresentational" painting, when common sense would demand that we recognize it in the same way that we do "representational" painting (which—incidentally—the partisans of "nonrepresentational" painting recognize as having an artistic value in no way "inferior" to theirs)?

There are, I think, two reasons:

First, there are the throngs of those who more or less completely lack any sense of painting, that is to say, who, in contemplating a tableau, see only the object "represented" by it, and who, as a result, can experience only the "sensations" and "feelings" that that object provokes in them, and [so who experience] the tableau only to the extent that it "represents" (one need only think of the success of certain "Nudes"). It is obvious that a "nonrepresentational" tableau does not exist for them, and it

is normal that they "deny" nonrepresentational painting. But it is obvious that, in denying it, these people deny painting itself: they do not know that there is something called "painting," and when they find themselves in the presence of something which is only "painting," they see *nothing*, and therefore say that it is nothing, that it is "nothing at all."

Then there are the people who think that they can distinguish a tableau from a colored surface (certain art critics, for example). Now, even for them, this distinction is always difficult, it always demands an effort (one need think only of the errors made by even the most competent critics!). In the realm of "nonrepresentational" painting the task is even more arduous than in the realm of "representational" painting. Here [in the case of representational painting], the purely technical perfection or imperfection (the attained degree of "resemblance," etc.)—easily observed—generally permits—although not always—the recognition of artistic perfection, or its absence: there [in the case of nonrepresentational painting] this aid is completely lacking. Thus out of intellectual laziness and an unacknowledged but felt fear of being deceived, many critics and "amateurs" refuse to even attempt the difficult task of appreciating the artistic value of a given "nonrepresentational" tableau; instead they prefer the easier route, to deny the value of "nonrepresentational" painting as such.

It is obvious that neither of these two motives can provide supporting evidence for that negation [i.e., the

denial of nonrepresentational painting]. And one might well say that that [evidence] cannot be provided, [the negation] being essentially absurd.

It is, therefore, generally only absurdities that one airs when speaking or writing against "nonrepresentational" painting. Is it not, for example, an absurdity to say that it is "easier" to paint a "nonrepresentational" tableau than a "representational" one, or that the former are easier to "imitate," and that all-purpose recipes for their production are easily given, or other things of this sort.

3. Certain people, who do not contest the artistic value of "nonrepresentational" tableaux, nevertheless want to see in them only works of *decorative* Art.

I cannot analyze here the essence of "decorative" Art. I will say only that, in my opinion, the entire domain of art can be divided into autonomous Art and decorative Art, and that, in all probability, there is no sense in attributing more artistic value to one of these Arts than to the other.

But what seems certain to me is that Kandinsky's "nonrepresentational" painting has nothing to do with decorative Art. There is a decorative Art of sight, as there is a decorative Art of hearing (music), etc. And there is a decorative painting, as there is decorative sculpture and architecture. And decorative painting can just as well be "representational" painting (in all of its genres) as "nonrepresentational." But Kandinsky's painting is not decorative.

"Decorative" painting, in contrast to "autonomous" painting, is called on to *add* a Beautiful to something that exists outside of painting [and] that is nonpictorial. Thus, one adds a Beautiful to a vase that one "decorates" by coloring it or embellishing it with a design, etc., the vase itself being able to incarnate a Beautiful that is its own, or not. The "decorative" Beautiful is, then, a Beautiful that is sustained [*se maintient*] not by itself alone, but which needs other things in order to be what it is supposed to be, that is, in order to be *a Beautiful*: the pictorial Beautiful of the painting that decorates a vase does not exist in that vase. (On these grounds, the "decorative" Beautiful approaches the "natural" nonartistic Beautiful: the Beautiful of a tree also needs the tree to be what it is—the Beautiful-of-a-tree.)

In contrast, the Beautiful of the "autonomous" painting, in order to be what it is, needs nothing, except the painting itself: the Beautiful of the *painted* tree does not need the tree to be what it is supposed to be, but only the tableau "Tree" ... And that is precisely why the "autonomous" tableau is not "decorative."[47]

Now, it is evident that Kandinsky's paintings are as little "decorative" as possible; they are just as "autonomous" as the tableaux by whatever other artist-painter one agrees to describe as non-decorative.

One could say, certainly, that Kandinsky's tableaux are called on to "decorate" an "interior." But that can be said of any tableau whatsoever. And in fact it is necessary to say that a tableau by Kandinsky, perhaps more than

any other, is called on much more to *be* "decorated" by an interior (by the "interior" of a museum gallery, for example) than *to* decorate an interior, that of a "boudoir," for example, which seems to be formed as if by magic, around such "valued" tableaux.

4. To close, I would like to present a diagram that can facilitate comprehension of my article, by making more visible the place that I assign to Kandinsky's art, or, if you prefer, to nonrepresentational painting, within the broad domain of art in general:[18]

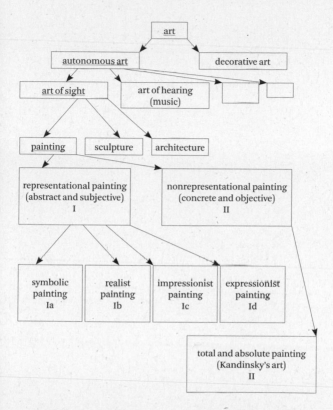

The diagram clearly shows that Kandinsky's painting is not, in my opinion, a fifth genre [or type] of painting in general, but a second, the first [i.e., representational painting] implying four species or subdivisions.

Vanves, July 23–25, 1936

Translator's Notes

The original, handwritten manuscript of the essay "Les Peintures concrètes de Kandinsky," the document translated here, is preserved in La Bibliothèque Kandinsky at the Centre Pompidou in Paris. To date, it has been published (in the original French) three times. The first time was in 1985—thus nearly fifty years after it was written—by Michael Roth in the *Revue de métaphysique et de morale* 90, no. 2 (April–June 1985), pp. 149–171; the second time was in a special issue of *Les Cahiers du Musée national d'art moderne* (hors série/archives) (Paris: December 1992), pp. 176–193; and the third time as a slim paperback volume by the Belgian publisher La Lettre volée (Brussels, 2001). It's worth noting that Kojève had initially titled the essay "The Objective Paintings of Kandinsky" before changing his mind and replacing "Objective" with the word "Concrete."

1 The words "Table of Contents" ("Analyse de contenu") are actually written—lightly, with pencil—not in Kojève's hand but in Kandinsky's. The "table" itself, however, is by Kojève.

2 During revision of the essay, Kojève deleted "an animal" from his list of potentially beautiful things outside of art, and added the more Kantian (or Soloviev-inspired) "birdsong" in its stead. He also scratched the sentences that immediately followed: "Thus Beauty and Art are not the same thing. But the Beautiful—in all its specializations—is always beautiful; there is the beautiful, one and the same, in all that is beautiful, in Art or outside of Art." For Soloviev's understanding of the nightingale's song (as "the transfiguration of the sexual instinct, its liberation from the crude physiological fact—... the animal sex instinct embodying in itself *the idea of love*"), see his essay "The Beauty of Nature," in S. L. Frank, ed., *A Solovyov Anthology*, trans. Natalie Duddington (London: SCM Press, 1950), esp. p. 129.

3 There is an interesting mistranscription of this sentence both in the version of the essay published by Michael Roth and, presumably as a result of that, in the small paperback edition released by La Lettre volée. In each, the sentence reads: "Un seul et même Beau s'incarne dans l'arbre réel et dans l'esprit peint." Kojève's handwriting could hardly be more legible: the penultimate word in the sentence is clearly *l'arbre* rather than *l'esprit*. The only explanation would seem to be that Roth—recognizing the generally Hegelian nature of Kojève's argument, and anticipating (somewhat incorrectly) the distinction that Kojève would soon draw between Beauty-in-Art and Beauty-outside-of-Art—projected "spirit" onto the painted tree. Ironically, the mistranscription calls our attention to the surprising absence of any reference to "spirit" in Kojève's text, and so also to the complicated

(if unarticulated) relation between Beauty and *Geist* implied by his argument.

4 Deleted phrase: "—like dirt on a table, which is there only by accident, insofar as it has not been mopped up, wiped away …"

5 The phrase that Kojève employs here, "étant 'en et pour soi,'" is a translation of *das An-und-für-sich* used by Hegel. For Hegel, Being that is "in-and-for-itself" is wholly complete and self-contained. To further emphasize its autonomy—that its existence is not determined through some other thing—Kojève will later add "by" (*par*) to the mix, referring to Being that is in-*by*-and-for-itself. Indeed Hegel himself used the phrase *Beisichselbstsein* (being self-sufficient, or at home with oneself), including in *The Philosophy of World History*, where he wrote: "spirit is self-sufficient being [*Beisichselbstsein*], and just this is freedom." See *Lectures on the Philosophy of World History: Introduction*, trans. H. B. Nisbet (Cambridge: Cambridge University Press, 1975), p. 48. For Kojève, then, following Hegel, the "in-by-and-for-itself" is yet another way of designating the Absolute.

6 The manuscript reads: "Il est évident que c'est seulement le *tableau* qui peut être en tant pure surface plane seulement, car la toile ne peut pas être *sans* profondeur"—rather than "*en* profondeur," as it appears in the Roth and paperback editions of the essay.

7 This entire paragraph (which may strike us as fairly digressive in the present context) picks up the thread of an argument about the role of line in painting that had animated much of Kandinsky's *Punkt und Linie zu Fläche* (*Point and Line to Plane*) (1926). See especially *Point and Line to Plane* [in *Kandinsky: Complete Writings on Art*, ed. Kenneth C. Lindsay and Peter Vergo (Boston: G. K. Hall, 1982)], p. 634, where Kandinsky complains of a common "conceptual confusion," in which "what belongs together (in the present case, painting and graphics) is painstakingly divorced. Line is here reckoned as a 'graphic' element that may not be employed for 'painterly' ends, although no essential difference between 'graphics' and 'painting' can be found."

8 When the essay was published in *Les Cahiers du Musée national*, it included a mistranscription of this sentence. The "il n'y aura—dans tous ces types—des tableaux" of the manuscript was printed as "il n'y a âme dans tous ces types de tableaux." The mistake seems similar in kind to the one mentioned previously (see n3), in the version of the essay published in *Revue de métaphysique et de morale*—though now the result is rather less Hegelian. Presumably this projection of "soul" (*âme*) onto Kojève's essay is an indirect consequence of the strongly "spiritualist" cast of so much of the Kandinsky scholarship.

9 No doubt there is plenty to be said about Kojève's chosen example of the "nonartistically Beautiful": a woman's breast. Perhaps it will

suffice here to say that the example is, obviously, highly overdetermined and, although clearly meant to demonstrate non-desirous contemplation (via the scholarly, authorial tone Kojève assumes throughout), somehow falls short of that goal.

10 Marginal note by Kandinsky: "Pure realism is abstract!"

11 The following section of Kojève's text, which seeks to differentiate among these four types of representational painting, echoes—and so seems to have been intended to rewrite—portions of Kandinsky's 1913 essay "Painting as a Pure Art" ("Malerei als reine Kunst") (*Kandinsky: Complete Writings on Art*, pp. 349–354). There, the artist distinguished three distinct periods within the history of art, the first characterized by "Realistic painting," the second by "Naturalistic painting (in the form of Impressionism, Neo-Impressionism, and Expressionism)," and the third, only then emerging, by "pure" (i.e., nonrepresentational) painting, which he designated as "compositional." The triadic form of Kandinsky's argument is perhaps more overtly Hegelian, yet Kojève apparently felt that it neither captured the full complexity of painting's historical development nor sufficiently emphasized the difference that had been achieved in and by Kandinsky's nonrepresentational painting.

12 Alongside the subtitle—(The Art of Kandinsky)—in the original manuscript, someone—the handwriting doesn't seem to be Kandinsky's, although it also looks a bit different from most of Kojève's—wrote (in pencil) "≠ *constructivisme*." In all of the previously published versions of the text, the symbol is mistakenly given as an equals sign, but the diagonal bar is plainly visible (if somewhat faint), and the clear intention seems to have been to differentiate Kandinsky's paintings from the work of the Russian constructivists, who had claimed the language of "concrete objectivity" for themselves.

13 At this point in the manuscript there is a word written in Kandinsky's hand—"повторение" (repetition)—and then a passage struck out. The deleted passage reads:

> In effect, the tableau "Tree"—and its Beauty—are abstract because the real tree is tall, deep, fragrant, hard, useful, resonant, etc., etc., whereas the "represented" tree is none of that. Now, the tableau "Circle-Triangle" *is* the circle-triangle, which is *nothing* outside of the tableau. Said otherwise, the circle-triangle is "itself" nothing more than its flat, visual aspect: "it" has no depth, "its" size is exactly the one it has in the painting, it is neither fragrant nor hard, useful nor resonant—in a word, "it" possesses no qualities other than those it has in the tableau. Thus, if the real tree has an infinity of visual aspects, while the tableau "Tree" "represents" only one of these aspects, the circle-triangle is noth-

ing other than the visual aspect that the tableau "Circle-Triangle" presents, which "represents" nothing. The tableau "Tree" shows us the "front" of the tree but hides what's "behind"; in contrast, there is nothing "behind" the aspect presented by the tableau "Circle-Triangle" (or, if you want, there is a behind: what you can see by looking at the tableau in a mirror, or the drawing through [its] transparency). The tableau "circle-triangle" and its Beauty are thus just as real and complete, that is, concrete, as the real tree and its Beauty.

14 In this passage, Kojève is clearly working to shield Kandinsky's art from any claims of subjectivity. He does this by distinguishing two separate moments within the making of a representational painting: an initial moment, when the artist imaginatively extracts or abstracts the Beautiful of the nonartistic object; and a second moment, when he or she successfully incarnates that "extracted" Beautiful in a tableau. The latter moment, Kojève insists, involves no abstraction whatsoever and is therefore also free from any subjectivity. By extension, because Kandinsky's art avoids that initial moment of "extraction," his works are wholly objective. We should also note, however, that in referring to each of the two differentiated moments as moments of the tableau's "birth" (rather than, say, its "creation"), Kojève seems to be alluding to a well-known if enigmatic passage from the Introduction to the *Aesthetics* in which Hegel asserts that the "beauty of art is beauty *born of the spirit and born again*" (*Hegel's Aesthetics: Lectures on Fine Art*, trans. T. M. Knox [Oxford: Oxford University Press, 1975], I, p. 2). Kojève's argument effectively makes sense of the "born again" part of that passage by explaining how the creation of a representational image involves two separate moments of "birth"; of course, in doing so, it also subtly insinuates that representational art was foremost on Hegel's mind when formulating the *Aesthetics*, his (fairly cursory) treatment of music notwithstanding.

15 I take this comment to have been intended to answer to the charges, frequently heard throughout the 1920s and '30s, that Kandinsky's art was overly theoretical or intellectual, and therefore insufficiently artistic.

16 Marginal note by Kojève:

People of late are trying desperately to create "objects." What is true and serious in this movement is the desire—unconscious or misunderstood—for concrete and objective, that is, total and absolute or "nonrepresentational" art, which—in the form of painting—is represented by Kandinsky. But one must not forget that it is not enough to pile up real, nonartistic objects in order to create an artistic one. In the vast majority of cases, the

creation of objects called "surrealist" has nothing to do with Art in the standard sense of the term, but at the very most with the art of deception, the art of those who succeed—in a pinch—at passing for mad—and even then only with the gullible (to be polite)—without really being mad (since the absence of common sense is simply foolishness, which is quite different from madness).

17 Kojève condensed—and substantially clarified—this argument in the shorter essay published in the journal *XX^e Siècle*:

Art is thus the art of producing beautiful objects. If the object produced also has a value other than its beauty, the art is an *applied* art: the artist "decorates," "embellishes" a thing (natural or fabricated). If beauty is the only value of the object produced, the art is *autonomous* (or "pure," as is generally said). It follows from this definition that, if God is an Artist, his art is necessarily "decorative" or "applied," whereas Kandinsky's art is autonomous, in that the objects made by him would be "without value" if they were not beautiful (their economic value then being "negative," since the producer will have "wasted" canvas and colors). [Alexandre Kojève, "Pourquoi concret," *XX^e Siècle*, no. 27 (December 1966), p. 65]

18 In Kojève's handwritten manuscript, the headings underlined here—"art," "autonomous art," and "art of sight"—were underlined with blue pencil, while the word "painting" was underlined in red. The Roman numerals and accompanying letters that differentiate among the various types of painting were also written in red pencil.

Letters to Kandinsky

Alexandre Kojevnikoff
18, rue Émile Dunois
Boulogne[-sur-]Seine

Boulogne[-sur-Seine], 3.II.29

Dear Uncle Vasya,

I recently visited your exhibition at [Galerie] Zak, which I had learned about by accident.

What you have exhibited is again so new that, during the first visit, I could hardly even tell what I personally "liked" more. Like the paintings of 1920–1921, your recent pieces at first seemed weaker to me than the works of 1914–1915. The same impression was made by the paintings in Dresden, compared with the pieces in the Kronprinzenpalais. Only after I had visited the exhibition a second time and was accustomed to the form did I realize the significance of your recent achievements. At the same time, the works of the "transitional" period also became clear to me.

I would like to express my thoughts that have arisen in this regard and learn your opinion about them.

The transition from figurative painting to non-figurative painting cannot cause serious debate. To assert that "depiction of reality" is never art's goal, but only a means of expressing something specifically aesthetic, is a truism not worth discussing. It is obvious. The only matter that can be debated is whether art only expresses the

artist's subjective "experience" of what is externally (or internally) given, so that the aesthetic moment originates and consists only in this "experience," or whether it describes (via words, sounds, colors, etc.) the *objectively* existing aesthetic nature of things (beauty?), which the artist does not create, but sees. This debate ultimately boils down to the contrast between (subjective) "idealism" and (Platonic) "realism" in the philosophical worldview, and it must be resolved within an integral philosophical "system." Therefore, it makes no sense to write about it in a letter. It suffices to note here that the question of the figurative or non-figurative character of a painting has nothing to do with this debate. I would also say that I personally support a "realistic" solution to the issue. There is no doubt, of course, that many artists (lyric poets, the Romantics, etc.) express their *personal* "experiences," but this expression becomes art only when "experiences" are perceived as objectively given, as entities objectively existing alongside "external" objects, and not as mental acts inextricably linked with a particular subject (for example, erotic dance is an art, but a loving caress is not).

From this point of view (and to avoid complicating the matter), we can regard artworks as autonomous "objects," beyond their connection to the artist's personality. I will adhere to this viewpoint in what follows. (For simplicity's sake I will limit myself to painting, although almost everything I say will apply to art more generally.)

All painting (including your works of 1914–1916) is typified by the following, in my opinion. In depicting the

aesthetic essence, it interprets not the world as a whole (*Totalität*), but artificially (artfully) isolated moments of it (*Begrenztheit*). In interpreting totality, painting would not always have to depict "the same thing." It is possible to distinguish an infinite number of the world's aesthetic aspects: each of them expresses the *whole* world, but in some particular aesthetic individuation. Painting used to depict not aspects of the world, but its moments, i.e., groups (*Inbegriffe*) of givens, isolated from the common bond, and aspects of *these groups*. Historically, this is explained, of course, by painting's objective end result: a group of objects would be singled out, and some aesthetic aspect of it was revealed. The group was always isolated and internally unified, but this unity was sometimes static, and sometimes dynamic, i.e., the group was either a unity of "forms" or a unity of "actions" (these terms are "approximate"). Superficially, this moment— the painting's unified group character—is expressed by the presence in it of a "center of gravity" uniting the entire composition. The picture is centered; its external boundaries are not random but are predicated on a limitation of the depiction. When the "group" is perceived statically (when the drawing predominates*), the picture's "center" nearly overlaps with the geometric center of gravity of the formed masses; when it is perceived dynamically (when the colors predominate*), it is the point of the dynamic equilibrium of "forces." (I say "predominate," since it is impossible to create pure stasis or dynamism.) As I have already said, as an expression of what is

limited, such a picture itself necessarily has boundaries (a frame), but as a limited picture it is not self-sufficient. It is enmeshed as an element in the context (the architectural "frame"; a degeneration: a picture hanging on the wall in a room).

It seems to me that your paintings also fit this general definition until quite recently: they did not integrate details (they had a center, top, bottom, and so on). If that is so, then their non-objectivity was not necessary, albeit quite possible. True, unification in your work was mainly dynamic and the non-objectivity made it easier to depict the unified dynamic entity's aesthetic aspect. But it seems to me that everything depicted could have been revealed by objective means. To repeat: there was no necessary and sufficient reason for rejecting figuration.

In my opinion, the situation with your latest paintings is completely different.

The pictures of the "transitional" period (for example, the watercolor that you gave me in Bln [*sic*]) are ambivalent. On the one hand, "centralism" seems to have reached its apogee in them. Everything is compressed into a closed whole and limited by itself. (Rather than by a "frame": the white border could be wider or narrower, but it doesn't matter!) The picture's unity resembled the unity before an explosion, however. (There are "protuberances" ◿ here and there, but the "wedges" ◸ and "brackets" ⌒ rein them in.) Everything looks set to explode, and no frames and borders will hold it back! It was almost pure dynamism. (The apparent increase

in the underdrawing's specific gravity is deceptive; the line here is *merely* the boundary of the color field, and it is no coincidence that there is no color variation inside the closed line.) The tense unity was pushed to the ultimate limit but was thereby already overcome (dialectically!): the equilibrium had ceased to be stable.

The explosion had finally happened.

When I saw your painting in Dresden (*Einige Kreise*, I think), I was struck by its lack of unity: there is no center, the boundaries are purely random, but at the same time, the picture's individual elements are significant only in their common bond. I regarded it then as a disadvantage, as the absence of a unifying idea, and only now have I understood, it seems to me, the meaning of what had happened. I believe it means that you have managed to shift from "moments" to "aspects." Your new pictures are only accidentally limited by the size of the paper and the canvas: in fact, they are as infinite as the world, whose aesthetic aspects they transform. Since they are infinite, they can have no "center" either; or what is the same, each of their points is a "center." The division into stasis and dynamism also loses its meaning: they are static and dynamic at the same time. (Does this synthesis not express by means of "speckled" colorful surfaces: does color's dynamic moment have a formal [i.e., static] internal architecture?) Finally, they are self-sufficient, needing neither an environment nor a synthesis with other arts: they are aspects of the totality as it is.**

It is impossible to go any further. Formally, one could

try to depict the world itself as the whole of *all* its aspects (all-unity), rather than the world's individual aspects, but in fact this is impossible: in philosophy, such attempts, if successful, lead to silence (mysticism: cf. the story of Brahman and the Vedas!); in painting, to "*black*" paintings. And this would no longer be a dialectical overcoming of any form of painting but of painting as such. There are no distinctions—philosophy, art, and so on—in absolute comprehension. There is only "fullness," "blackness," and meaningful silence there.

In conclusion, a few minor questions:

1. If my interpretation is correct, does it not follow that your new paintings should, strictly speaking, be painted on a sphere, rather than on a plane? Would you try it? Of course, this is just a technical detail, but still the attempt would be interesting, in my opinion.

2. How (technically) do you make your "speckled" colorful fields (especially "backgrounds")?

3. What is your attitude to Klee? I saw his paintings in Germany and, as far as I remember, they look somewhat like yours. Yet their inner meaning is completely different. Is this a completely different trend, or is it difference of "talents"?

4. What do you think about Tériade's preface to your exhibition catalogue?

A. Kojevnikoff

And now for personal matters. The fact that I had not written to you is, of course, not because I had forgotten you. As a matter of fact, there is no explanation for it except our family's aversion to letters. You know that I not only appreciate you as an artist, but simply really love you. I won't apologize—it is pointless—but I am confident that I have not "offended" you.

You probably know that I am married.

My financial circumstances had been good, but now they are quite deplorable.

I finished university and passed the doctoral exam, although I did not receive an official diploma, having failed to publish my book (on Solovyov) for lack of money. The book is weak, however, and I have no desire to print it.

I have written some things, but I have not published anything. There is no point yet.

I have been mostly doing mathematics lately, and I had been working on Eastern philosophy. All, of course, as a means to an end—a philosophical "system."

We live in a tiny house on the outskirts of Paris.

I would really like to see you, of course, but I hope that I won't be coming to Germany soon. ("I hope," since going there would mean my having to find gainful employment.) Do you have plans to come to Paris? You could stay with us, of course. By the way, Mom is coming here in March or April. Bye-bye, greetings to you and your wife from me and my wife.

Your A. K.

* Arabesque, with its repetitions, does not overcome this situation. A feeble attempt is possible, perhaps. It is found in Chinese painting, in which some paintings are not contemplated as a whole, but gradually unfold before our eyes. But this is a purely superficial overcoming, of course.

** And if this is the case, then for these (and, as it seems to me, only for these) paintings, non-objectivity is not only one of the possibilities, but the only possible and necessary form.

Boulogne, 27.V.30

Dear Uncle Vasya,

I want to tell you something about [Joseph] Szigeti. My wife recently met them at some friends'. During the conversation, it somehow transpired that you were my uncle. Upon hearing this, S. excitedly explained the misunderstanding that had occurred, spoke with great admiration about you as the greatest modern painter, etc. He ultimately said that he would go to me the very next day and make an official apology! My wife had a hard time persuading him not to do it. His wife was more reserved, however. About two years ago I was at the exhibition of Braque and others which you saw. I liked Braque's paintings, especially the large ones. But Picasso exasperated me, finally. While there were no jaws there, [*illegible*] madmen were richly represented. . . . In my opinion, what he is doing now is a clear mockery of the public. His painterly manner itself demonstrates that he might certainly not be thinking deeply at all about what he is doing. Such "paintings," for example, as the profile of a woman(?) with teeth or twisted legs against a red curtain have no place in a serious exhibition. The juxtaposition with Braque is fatal to him. It is a pity that a talented person has let himself go so badly and stooped so low. Could he have been swayed and brought to reason, at least by giving him a thorough scolding in one of the serious art magazines?

I'm going to an exhibition of Klee's watercolors tomorrow.

It is quite doubtful I shall be able to come to Germany. We will probably spend the summer at home again. I received a letter from my mother: there are no hopes of her leaving.

I have not visited Mela for a very long time.

I am not writing anymore for the time being. With heartfelt greetings to you and N. N. from both of us.

Your A. K.

Boulogne, 20.IX.31

Dear Uncle Vasya,

I received your seven watercolors safe and sound. To avoid any misunderstandings, I shall deliver them personally in early October.

I immediately unpacked them and was amazed by the picture "Fleckig" (No. 432, 1931). This, in my opinion, is one of your best pieces (watercolors). Again, it is something completely new. I do not undertake now to define this newness, but it is immediately tangible as such. Superficially, it manifests itself in the way the rectilinear geometricity of the figures is violated. One has the impression that the "creative impulse" has become cramped in its readymade traditional forms, which have begun to ossify, and that it tears them from the inside, in the guise of paint spilling over the boundaries of the drawing. The vivid, juicy, downright coarse colors correspond adequately to this spontaneous power of creativity. The painting struck me at first sight as congenial in a way to some of Picasso's works. Then I realized that the "similarity" is based precisely on the *strength*, immediacy, and tension of the pictorial content, which is so typical of Picasso's (genuine and serious) works.

I am continually amazed at your ability to find more and more new forms for your painting. Only Picasso can compare with you in this regard. But unlike him, you

never permit yourself affectation, outrageousness, etc. Yes, there is much more taste, tact, intelligence, and skill in your pictures. However, this great advantage is sometimes a disadvantage; after all, you are often, and sometimes rightly, reproached for being cerebral. I myself believe that some of your paintings are illustrations to your theory of painting rather than straightforward painting. In this sense, you remind me of Leonardo da Vinci.

As for the other pictures, they are good, of course. They are genuine art, like everything you do, but, in my opinion, they are much inferior to No. 432. A traditional approach to form is strongly visible in them. Although you created it yourself, it has already hardened. It seemingly does not grow organically from the painting's pictorial content, but replaces this content itself. The picture is more like a (very talented and subtle, but not masterful) combination of readymade forms.

It is no accident, in my opinion, that some of them resemble the watercolors of Klee, that master of *Kleinkunst* and all manner of virtuosity. This, of course, is not a "reproach," since no artist can be at the utmost height of creative power and spontaneity in all his works (even Rembrandt, who is nearer to this ideal, does not fully embody it). And you deserve this reproach less than anyone. But I wanted to note this difference between No. 432 and the other six. (I won't talk about them separately; personally, I really "like" Nos. 378 and 382.)

It is curious that I showed your watercolors to a complete "layman" in painting and he immediately singled

out No. 432. I have always said that real masterpieces should appeal to everyone (to the unbiased).

In connection with your paintings, I have come up with an overall idea concerning the history of painting (and art in general). What I said about the history of an individual artist's oeuvre applies to the history of painting as a whole. Here too the individual genius creates a new form and a real genius always creates it—it is his power that does not fit within the traditional framework. These forms are then adopted by less original artists who use them to produce talented paintings. At the same time, the process by which these forms ossify begins and art turns into the *ability* (I am not talking about the *inability* of the incompetent) to wield them. If a genius again appears, he can no longer be satisfied with such "skill" and, precisely due to the ossification of forms, he is forced to create new ones. And so on and so forth.

Here you can see a "justification" and conceptualization of non-figurative (sorry, but I cannot write "abstract") painting's emergence. But this conceptualization is quite superficial; I have seemingly found a more profound one. While working on my book on atheism, I have been thinking about the essence of art (as opposed to religion) and it seems to me that a metaphysical justification of non-figurative art follows from what I have concocted. But I cannot write about it now—it is too complicated. We shall talk when we see each other. If I manage to come to Dessau, I shall stay longer and maybe I will write an article on this topic in rapport with

you. There is nothing new in my life. I have been working quite a lot and almost never go anywhere. It's a pity you won't see the [1931 Paris International] Colonial Exposition: it is quite beautiful in the evening. All the best for now. Warm greetings to you and Nina Nikolaevna.

Your A. K.

The Personality of Kandinsky

What was most striking about Kandinsky, to those who knew him intimately, was the astonishing harmony of his entire life, as well as of the very personality that this life expressed. A life without conflicts, without disputes, without visible personal upheaval. A personality without sharp angles, without either apparent or real dissymmetries. An artistic and private life that flowed naturally, as a whole and in its smallest details, from a personality complete within itself. A personality that was able to express itself entirely through life and in works of art, without that expression having disfigured it in any way.

What has been said about the opposition between classicism and romanticism still remains valid, and we must have recourse to it if we want to express ourselves succinctly. Thus, if in comparing Kandinsky's life to the great romantic existences, one is tempted to proclaim it "bland" or "banal," that judgment can only be corrected by noting that this life was essentially classical: which is to say, lucid and serene, and surprisingly balanced.

As with all true classicism, this balanced life was not achieved by Kandinsky at the expense of "power" or "tension." And the harmony of his personality was not purchased at the cost of a simplification that would have amounted to impoverishment. On the contrary, it is precisely the extreme richness of such a personality that determines its internal and manifest harmony. The equilibrium was there only because each point was balanced by its counterpoint. The feelings—familial, social, political—could therefore be deep and strong: they

upset nothing because they were in harmony with each other and with the whole. Reason could thus remain lucid and serene while contemplating the harmonious balance of a life that was itself passionate and intense.

A man who, at thirty years of age, could abandon a brilliant career as a scholar and jurist to devote himself entirely to painting was certainly no stranger to "passion." But because the need for art and for scholarly or scientific research simply expressed two complementary aspects of a single personality at one with itself, this radical transposition of existence provoked no conflict. And it was again without either upheaval or conflict that Kandinsky was able to live and work in different political climates and in very diverse cultural environments. Multifaceted himself, he easily integrated all that was true, beautiful, and good. Only evil, in all its forms, was absolutely unacceptable to him. This is why he was able to paint and teach in Weimar Germany, whereas all he would accept from Hitler's government was an exit visa....

It is perhaps in contemplating Kandinsky's pictorial work that one understands him best as a man. Certainly his paintings are nothing less than "expressionist," but it was not to "express" himself that he took up the brush. His paintings [*tableaux*] and drawings were intended to reveal the objective aspects of being, inexpressible other than by way of shapes and colors. Through his art, he saw and showed in reality what he himself had realized

in his own existence, expressing it through his person-
ality: a personality that was calm, balanced, and serene,
with a contrapuntal and harmonious complexity con-
crete in its universality.

Vanves, July 21, 1946

ALEXANDRE KOJÈVE (1902–1968), born in Moscow to a bourgeois family, was a philosopher and statesman who greatly impacted twentieth-century French philosophy. Educated in Berlin and Heidelberg, Germany, Kojève completed his PhD thesis on Vladimir Solovyov, a Russian religious philosopher influenced by Hegel. After moving to France, he gained acclaim for his lectures on Hegel's *Phenomenology of Spirit*, held at the École Pratique des Hautes Études in Paris from 1933 to 1939. Attended by many French intellectuals of the day, including Georges Bataille, André Breton, Jean-Paul Sartre, and Jacques Lacan, Kojève's lectures were later published in French (1947) and English (1969). In 1936, Kojève wrote an influential text on the concrete paintings of his uncle, the abstract artist Wassily Kandinsky. After World War II, Kojève worked in the French Ministry of Economic Affairs, where he was instrumental in shaping the country's foreign trade and economic policies. He was a central participant in negotiations leading to the General Agreement on Tariffs and Trade (now the World Trade Organization), and his work brokering the Treaty of Rome helped establish the European Economic Community (now the European Union).

BORIS GROYS is a professor at the College of Arts and Science, New York University, and professor of philosophy and art history, The European Graduate School, Saas-Fee, Switzerland. He is the author of the books *Introduction to Antiphilosophy*, *Under Suspicion: A Phenomenology of Media*, *On the New*, *In the Flow*, *Logic of the Collection*, and *Philosophy of Care*.

"Ekphrasis" is traditionally defined as the literary representation of a work of visual art. One of the oldest forms of writing, it originated in ancient Greece, where it referred to the practice and skill of presenting artworks through vivid, highly detailed accounts. Today, "ekphrasis" is more openly interpreted as one art form, whether it be writing, visual art, music, or film, that is used to define and describe another art form, in order to bring to an audience the experiential and visceral impact of the subject.

The *ekphrasis* series from David Zwirner Books is dedicated to publishing rare, out-of-print, and newly commissioned texts as accessible paperback volumes. It is part of David Zwirner Books's ongoing effort to publish new and surprising pieces of writing on visual culture.

OTHER TITLES IN THE *EKPHRASIS* SERIES

On Contemporary Art
César Aira

Something Close to Music
John Ashbery

The Salon of 1846
Charles Baudelaire

Strange Impressions
Romaine Brooks

A Balthus Notebook
Guy Davenport

Ramblings of a Wannabe Painter
Paul Gauguin

Thrust: A Spasmodic Pictorial History of the Codpiece in Art
Michael Glover

Visions and Ecstasies
H.D.

Pissing Figures 1280–2014
Jean-Claude Lebensztejn

The Psychology of an Art Writer
Vernon Lee

Degas and His Model
Alice Michel

28 Paradises
Patrick Modiano and Dominique Zehrfuss

Summoning Pearl Harbor
Alexander Nemerov

Chardin and Rembrandt
Marcel Proust

Letters to a Young Painter
Rainer Maria Rilke

The Cathedral Is Dying
Auguste Rodin

Giotto and His Works in Padua
John Ruskin

Duchamp's Last Day
Donald Shambroom

Dix Portraits
Gertrude Stein

Photography and Belief
David Levi Strauss

The Critic as Artist
Oscar Wilde

Oh, to Be a Painter!
Virginia Woolf

Two Cities
Cynthia Zarin

FORTHCOMING IN 2023

Blue
Derek Jarman

Mad about Painting
Katsushika Hokusai

Kandinsky: Incarnating Beauty
Alexandre Kojève

Published by
David Zwirner Books
529 West 20th Street, 2nd Floor
New York, New York 10011
+ 1 212 727 2070
davidzwirnerbooks.com

Project Editor: Elizabeth Gordon
Editorial Coordinator:
Jessica Palinski
Proofreaders: Anna Drozda,
Michael Ferut
Design: Michael Dyer / Remake
Production Manager: Luke Chase
Color separations: VeronaLibri,
Verona
Printing: VeronaLibri, Verona

Typeface: Arnhem
Paper: Holmen Book Cream, 80 gsm

Publication © 2022
David Zwirner Books

Introduction © 2022 Boris Groys

Texts by Alexandre Kojève © 2022
Nina Kousnetzoff

"The Concrete Paintings of
Kandinsky," translated from
the French by Lisa Florman,
was first published in Florman's
*Concerning the Spiritual and the
Concrete in Kandinsky's Art* in
2014 by Stanford University Press.
Reprinted with permission. For
information on the first publication
of "The Concrete Paintings of
Kandinsky," in French, see p. 66.

The letters on pp. 72–86 were
translated from the Russian
by Thomas H. Campbell.
The translation was made from
a typescript of the handwritten
letters, held at the Fonds Vassily
Kandinsky at the Centre Georges
Pompidou, Paris. Translated
and printed with permission.

"The Personality of Kandinsky"
was translated from the French
by Lisa Florman. The original
French manuscript is held at the
Fonds Alexandre Kojève at the
Bibliothèque nationale de France,
Paris. Translated and printed
with permission.

Frontispiece: Musée National
d'Art Moderne/Centre Georges
Pompidou, Paris. Artwork © 2022
Artists Rights Society (ARS),
New York. Digital image © CNAC/
MNAM, Dist. RMN-Grand Palais/
Art Resource, NY; p. 17: Image
published in Wassily Kandinsky,
Point and Line to Plane, trans.
Howard Dearstyne and Hilla Rebay
(New York: Solomon R. Guggenheim
Foundation, 1947). Artwork © 2022
Artists Rights Society (ARS), New
York. Photo courtesy Solomon R.
Guggenheim Foundation

ISBN 978-1-64423-081-7

Library of Congress
Control Number: 2022912938

Printed in Italy